SECOND BOOK OF IMPORTANT DATES

ILLUSTRATED WITH ELEANOR GILPATRICK'S LANDSCAPE PAINTINGS

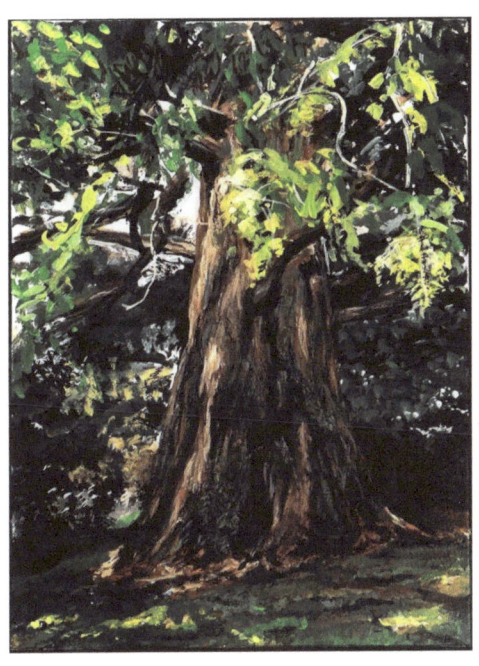

PLEASE NOTE:

The images presented in this book are based on the RGB color system, used when digital images are produced from photographs of paintings. With publication in a book, the CMYK color system is used. Documents that move from a computer screen to a printed page are affected by the fact that there are RGB colors that CMYK printers cannot reproduce. Something that looks good on a monitor may not look the same when printed. To overcome this limitation I have reviewed each printed page in a proof copy, and have made changes to bring the printed pages into as close a representation of the actual paintings as possible.

But the process is not perfect; and a small amount of variance from unit to unit is expected. The color may vary slightly from print run to print run and day to day.

I hope that you will enjoy this book; I encourage you to view the online website where images of the paintings are presented: www.zibbet.com/Egilpatr

Eleanor Gilpatrick

Cover Image:
Returning From Murano; 14 x 24 inches

Title Page Image:
Old Timer at Winterthur; 16 x 12 inches

Biography Page Image:
Fog Effect; 15 x 35 inches

Book design: Eleanor Gilpatrick

ISBN: 1448630517
EAN-13: 9781448630516

All images © Eleanor Gilpatrick. Images may not be reproduced in any way without permission of the artist.

Copyright © Eleanor Gilpatrick 2009

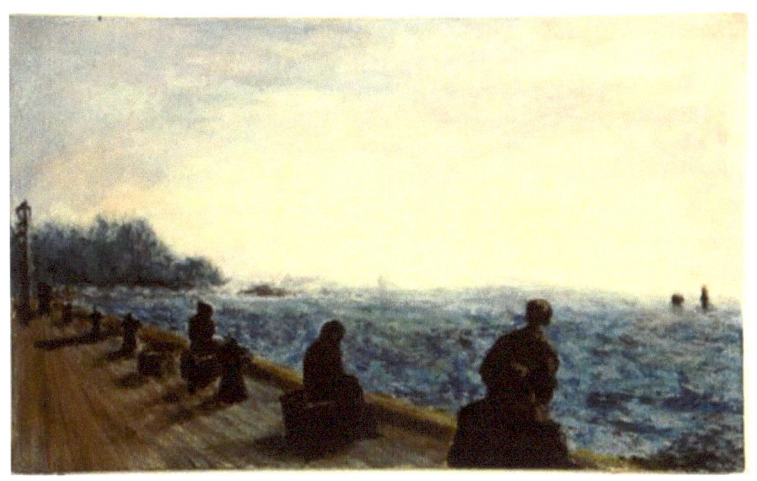

JANUARY

January is set in Venice. It was a cold January, and people were huddled against the cold, in the dusk, waiting for the Vaporetto near San Marco.

The painting is acrylic on stretched canvas, 18 inches high by 30 inches wide. It is framed, 20 inches high by 32 inches wide. The original is listed and may be seen at www.zibbet.com/Egilpatr

JANUARY

1_____

2_____

3_____

4_____

5_____

6_____

7_____

8_____

9_____

10_____

11_____

12_____

13_____

14_____

15_____

16_____

JANUARY

17 _____

18 _____

19 _____

20 _____

21 _____

22 _____

23 _____

24 _____

25 _____

26 _____

27 _____

28 _____

29 _____

30 _____

31 _____

FEBRUARY

Above Oslo is part of my "Inspired By Norway" series. Norway enchanted me, and I was there several times, moving between Oslo and Bergen by way of the railroad and by boat on the Sognefijord. This painting recalls a trip to the high hill above Oslo where the Olympics once took place: Holmenkollen. We found a restaurant in a hotel there, and emerged after dinner to see the late-setting sun.

The painting is 22 inches high by 35 inches wide; acrylic on stretched canvas, on heavy duty stretchers, with painted sides. The painting may be seen at www.zibbet.com/Egilpatr

FEBRUARY

1 _____

2 _____

3 _____

4 _____

5 _____

6 _____

7 _____

8 _____

9 _____

10 _____

11 _____

12 _____

13 _____

14 _____

15 _____

16 _____

FEBRUARY

*17*_____

*18*_____

*19*_____

*20*_____

*21*_____

*22*_____

*23*_____

*24*_____

*25*_____

*26*_____

*27*_____

*28*_____

*29 LEAP YEAR!*_____

MARCH

From The Terrace is one of my "From My New York Windows" series. My terrace in New York City looks out over the Hudson River towards New Jersey, and the sky can be amazing. This is 26 by 26 inches, acrylic on stretched canvas in a shadow frame; the framed dimensions are 28 x 28 inches. This painting is now in a private collection.

MARCH

1. ___
2. ___
3. ___
4. ___
5. ___
6. ___
7. ___
8. ___
9. ___
10. ___
11. ___
12. ___
13. ___
14. ___
15. ___
16. ___

MARCH

17 _____

18 _____

19 _____

20 _____

21 _____

22 _____

23 _____

24 _____

25 _____

26 _____

27 _____

28 _____

29 _____

30 _____

31 _____

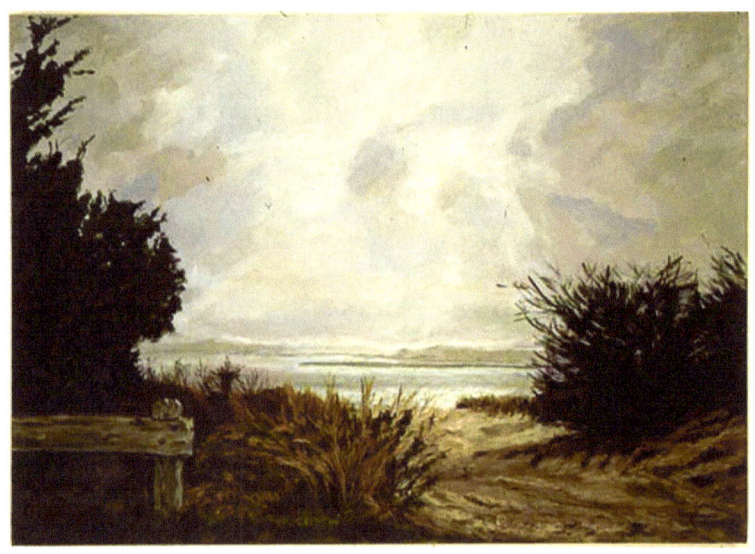

APRIL

East Hampton Light is part of the "Places I Love In America" series. The series is not a survey of the United States, just the places I have visited that moved me to paint. In April there can be misty days in the Hamptons, NY, and this day made me believe I was in a different world.

The painting is 23 by 23 inches, acrylic on stretched canvas, on heavy duty stretchers, with painted sides. See the painting at www.zibbet.com/Egilpatr

APRIL

1 _____

2 _____

3 _____

4 _____

5 _____

6 _____

7 _____

8 _____

9 _____

10 _____

11 _____

12 _____

13 _____

14 _____

15 _____

16 _____

APRIL

17 _____

18 _____

19 _____

20 _____

21 _____

22 _____

23 _____

24 _____

25 _____

26 _____

27 _____

28 _____

29 _____

30 _____

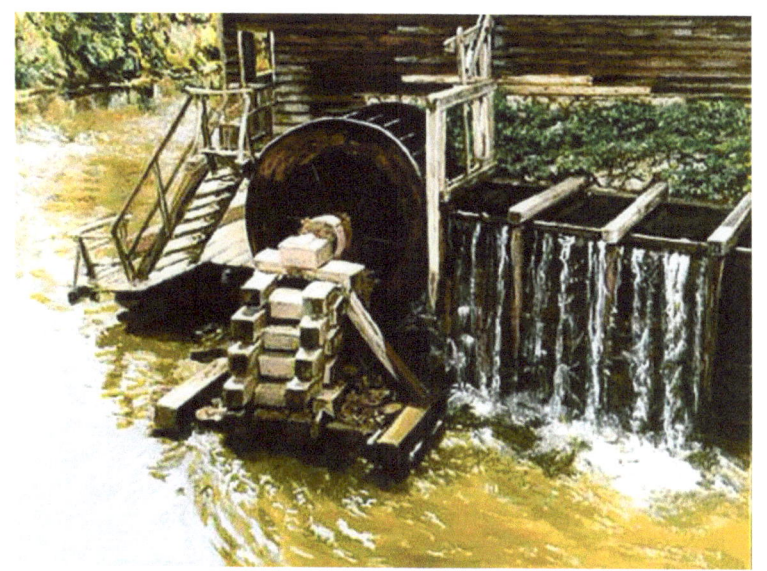

MAY

The Mill At Philipsburg Manor is part of the "Places I love in America" series. The series is not a survey of the United States, just the places I have visited that moved me to paint. Here is one of the places in New York State that I love. In Tarrytown, NY, the Philipsburg Manor is a place to go and see restored and preserved history. Here is the wonderful old grist mill, still turning.

The painting is 22 inches high by 30 inches wide; acrylic on stretched canvas, on heavy duty stretchers, with painted sides. The original painting is listed at www.zibbet.com/Egilpatr

MAY

1 _____
2 _____
3 _____
4 _____
5 _____
6 _____
7 _____
8 _____
9 _____
10 _____
11 _____
12 _____
13 _____
14 _____
15 _____
16

MAY

17 _____

18 _____

19 _____

20 _____

21 _____

22 _____

23 _____

24 _____

25 _____

26 _____

27 _____

28 _____

29 _____

30 _____

31 _____

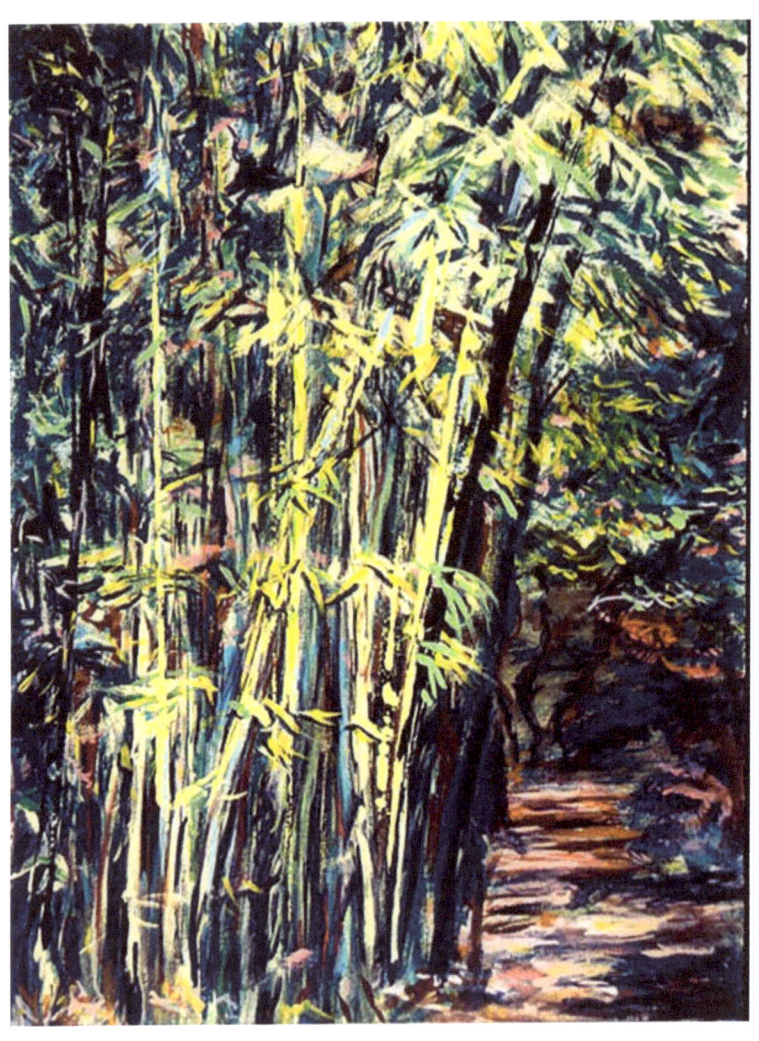

JUNE

Bamboo in Lucca tells about that June I was exploring the delightful city of Lucca, in Italy. The Palazzo Moriconi Controni Pfanner has a fabulous garden; it is open to the public, and includes a large stand of bamboo that has a path and makes one feel it is native to the spot. It is 26 inches high by 20 inches wide, acrylic on stretched canvas; the framed dimensions are 28 by 22. See it at www.zibbet.com/Egilpatr

JUNE

1 _____

2 _____

3 _____

4 _____

5 _____

6 _____

7 _____

8 _____

9 _____

10 _____

11 _____

12 _____

13 _____

14 _____

15 _____

16 _____

JUNE

*17*_____

*18*_____

*19*_____

*20*_____

*21*_____

*22*_____

*23*_____

*24*_____

*25*_____

*26*_____

*27*_____

*28*_____

*29*_____

*30*_____

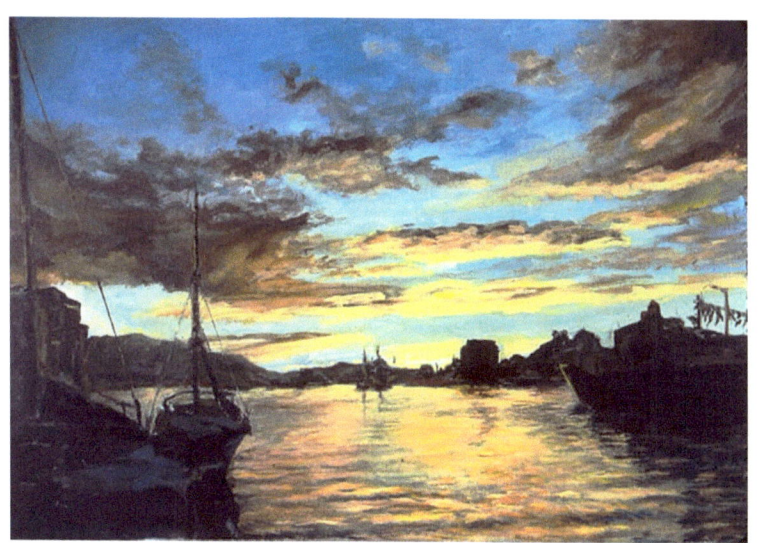

JULY

My series, "Inspired By Norway," includes paintings I did after being in Norway several times, moving between Oslo and Bergen by train and via boat on the Sognefijord.

Bergen, 11 PM was the first in the series. Here is the land of the midnight sun! It was eleven at night and the sun was just then setting in Bergen as we looked out over the water from the outdoor fish market to admire the amazing sky. This painting is acrylic on stretched canvas, 18 inches high by 27 inches wide; framed, it is 20 by 28 inches. It is now in a private collection.

JULY

1 _____

2 _____

3 _____

4 _____

5 _____

6 _____

7 _____

8 _____

9 _____

10 _____

11 _____

12 _____

13 _____

14 _____

15 _____

16 _____

JULY

17 _____

18 _____

19 _____

20 _____

21 _____

22 _____

23 _____

24 _____

25 _____

26 _____

27 _____

28 _____

29 _____

30 _____

31 _____

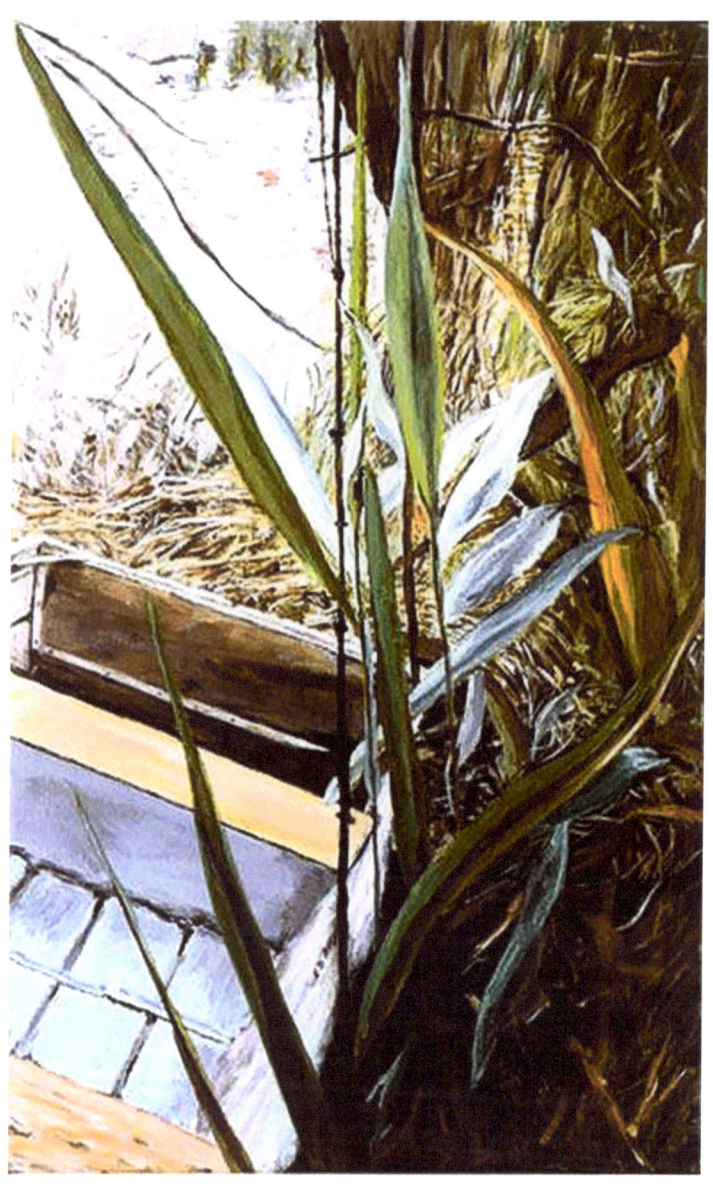

AUGUST

Secret is set in Stony Brook, NY, behind the old grist mill, and we were wandering around. I found this abandoned boat. Was it someone's secret? Why was it here? This is 27 inches high by 17 inches wide, acrylic on stretched canvas on heavy duty stretchers. It can be seen at www.zibbet.com/Egilpatr

AUGUST

1_____

2_____

3_____

4_____

5_____

6_____

7_____

8_____

9_____

10_____

11_____

12_____

13_____

14_____

15_____

16_____

AUGUST

17 _____

18 _____

19 _____

20 _____

21 _____

22 _____

23 _____

24 _____

25 _____

26 _____

27 _____

28 _____

29 _____

30 _____

31 _____

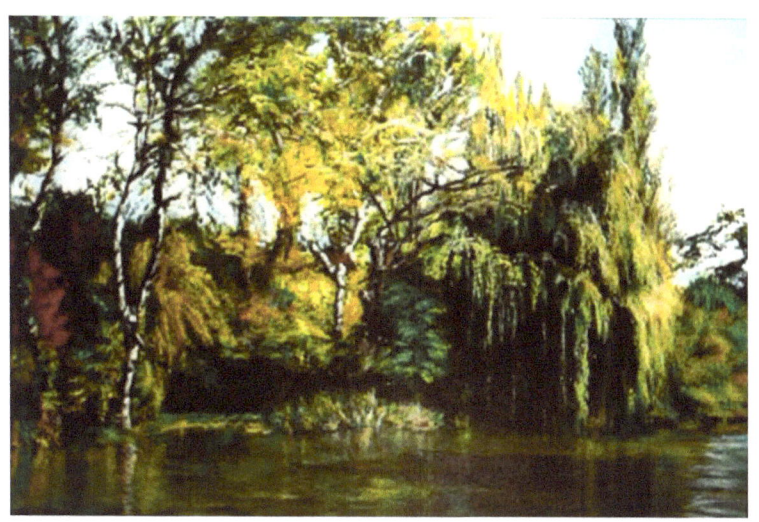

SEPTEMBER

View On The Kamchia is part of my "Inspired By Bulgaria" series. This was a view on the Kamchia River in Bulgaria, from a boat that was going up the river for us as tourists, for the joy of it. This side of the river was virgin, unspoiled forest, and it presented a lush display.

The painting is 24 inches high by 36 inches wide, acrylic on stretched canvas on heavy duty stretchers, with painted sides. The painting is listed online at www.zibbet.com/Egilpatr

SEPTEMBER

*1*_____

*2*_____

*3*_____

*4*_____

*5*_____

*6*_____

*7*_____

*8*_____

*9*_____

*10*_____

*11*_____

*12*_____

*13*_____

*14*_____

*15*_____

*16*_____

SEPTEMBER

17 _____

18 _____

19 _____

20 _____

21 _____

22 _____

23 _____

24 _____

25 _____

26 _____

27 _____

28 _____

29 _____

30 _____

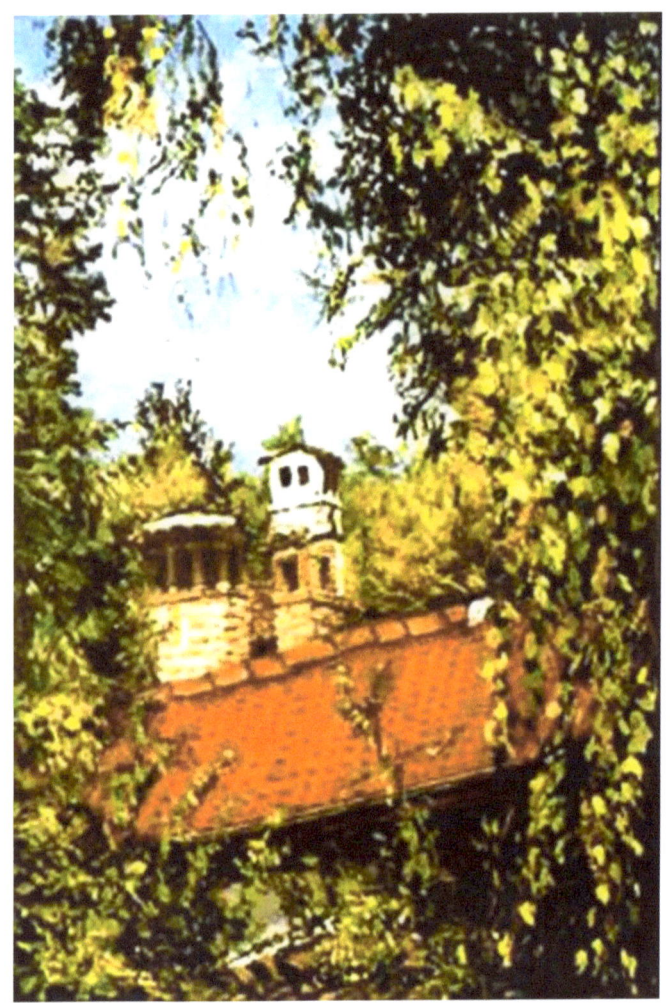

OCTOBER

October in Koprivshtitsa captures a typical rooftop in old Bulgaria. Koprivshtitsa is a wonderful museum town, and I fell in love. The painting is the first of my "Inspired By Bulgaria" series. I was entranced during a two-week trip to Bulgaria. The painting is 24 inches high by 15 inches wide, acrylic on stretched canvas on heavy duty stretchers, with painted sides. It can be seen on www.zibbet.com/Egilpatr

OCTOBER

1 _____

2 _____

3 _____

4 _____

5 _____

6 _____

7 _____

8 _____

9 _____

10 _____

11 _____

12 _____

13 _____

14 _____

15 _____

16 _____

OCTOBER

*17*___

*18*___

*19*___

*20*___

*21*___

*22*___

*23*___

*24*___

*25*___

*26*___

*27*___

*28*___

*29*___

*30*___

*31*___

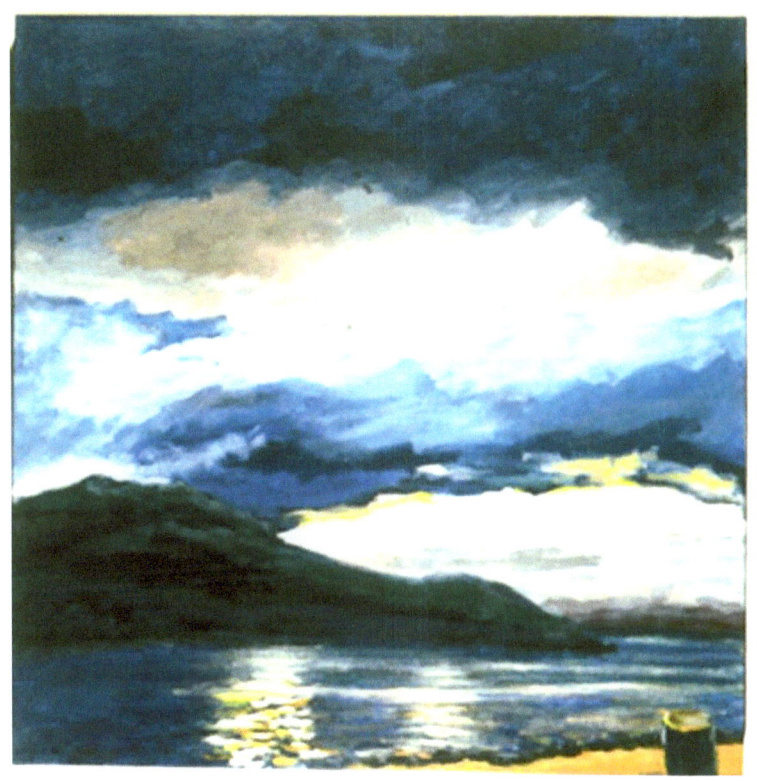

NOVEMBER

Fijord View II is part of my "Inspired By Norway" series. It had rained earlier; but we still went out in a boat to see the area around Balestrand on the Sognefijord. The sky was arresting. In the painting I played on the colors, especially orange and blue. The painting is 23 by 23 inches, acrylic on stretched canvas on heavy duty stretchers, with painted sides. It can be seen at www.zibbet.com/Egilpatr

NOVEMBER

1_____

2_____

3_____

4_____

5_____

6_____

7_____

8_____

9_____

10_____

11_____

12_____

13_____

14_____

15_____

16_____

NOVEMBER

17 _____

18 _____

19 _____

20 _____

21 _____

22 _____

23 _____

24 _____

25 _____

26 _____

27 _____

28 _____

29 _____

30 _____

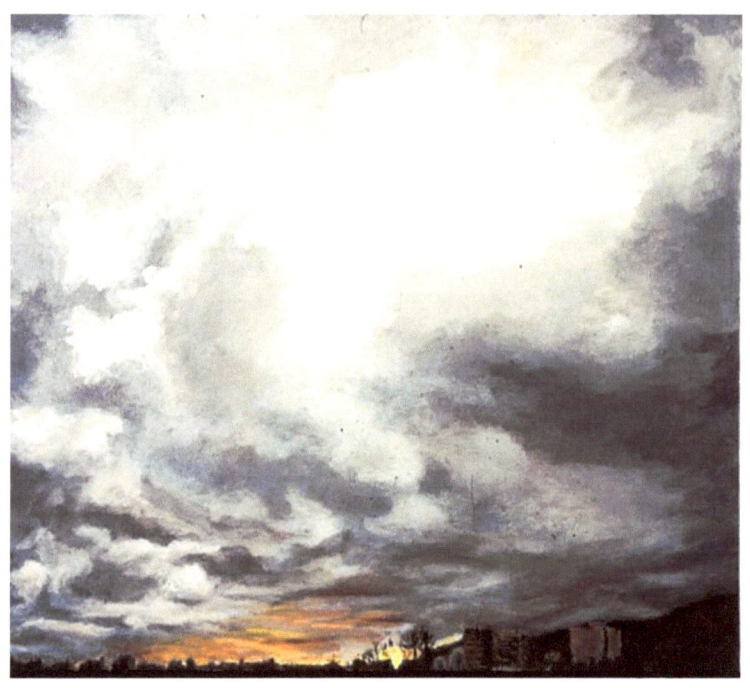

DECEMBER

Sunset, Costa del Sol reminds me of when I used to go to Costa del Sol, Spain, in winter, between semesters, when I was teaching. I stayed at the Castillo de Santa Clara, which had rooms looking out over the sea, the beach, and distant towns along the coast. This was a sunset from an open window. Alas, the Castillo is a condo now, and the beaches have been "modernized."

The painting is 27 inches high by 30 inches wide, acrylic on canvas, and is framed; the framed dimensions are 29 inches high by 32 inches wide. It is on view at www.zibbet.com/Egilpatr

DECEMBER

1 _____

2 _____

3 _____

4 _____

5 _____

6 _____

7 _____

8 _____

9 _____

10 _____

11 _____

12 _____

13 _____

14 _____

15 _____

16 _____

DECEMBER

17 _____

18 _____

19 _____

20 _____

21 _____

22 _____

23 _____

24 _____

25 _____

26 _____

27 _____

28 _____

29 _____

30 _____

31 _____

BIOGRAPHY

Eleanor Gilpatrick is a contemporary realist, painting landscapes, figural works, and still lifes that capture fragments of the world. They arrest the viewer in terms of composition, color, and content. Illustrated in this book are some of her favorite landscapes, based on her trips to Bulgaria, Italy, Norway, and within the United States.

Prior to her art career, Eleanor Gilpatrick was professor at the School of Health Sciences, Hunter College, City University of New York.

She won prizes for painting and draftsmanship in high school and at the Educational Alliance in New York City, but chose to study the social sciences in college and graduate school. She eventually became an expert in health care policy and human resources, authored four books, directed a masters program in health services administration, and pioneered courses in critical thinking and writing. She is Professor Emerita at Hunter College.

Gilpatrick picked up the thread of drawing and painting in 1998 in plein-air workshops in Italy, and returned to serious study in studio courses at Hunter College just before she retired. An inventory of her paintings is on display at: www.zibbet.com/Egilpatr

www.ingramcontent.com/pod-product-compliance
Lightning Source LLC
Chambersburg PA
CBHW041115180526
45172CB00001B/266